THIS BOOK BELONGS TO

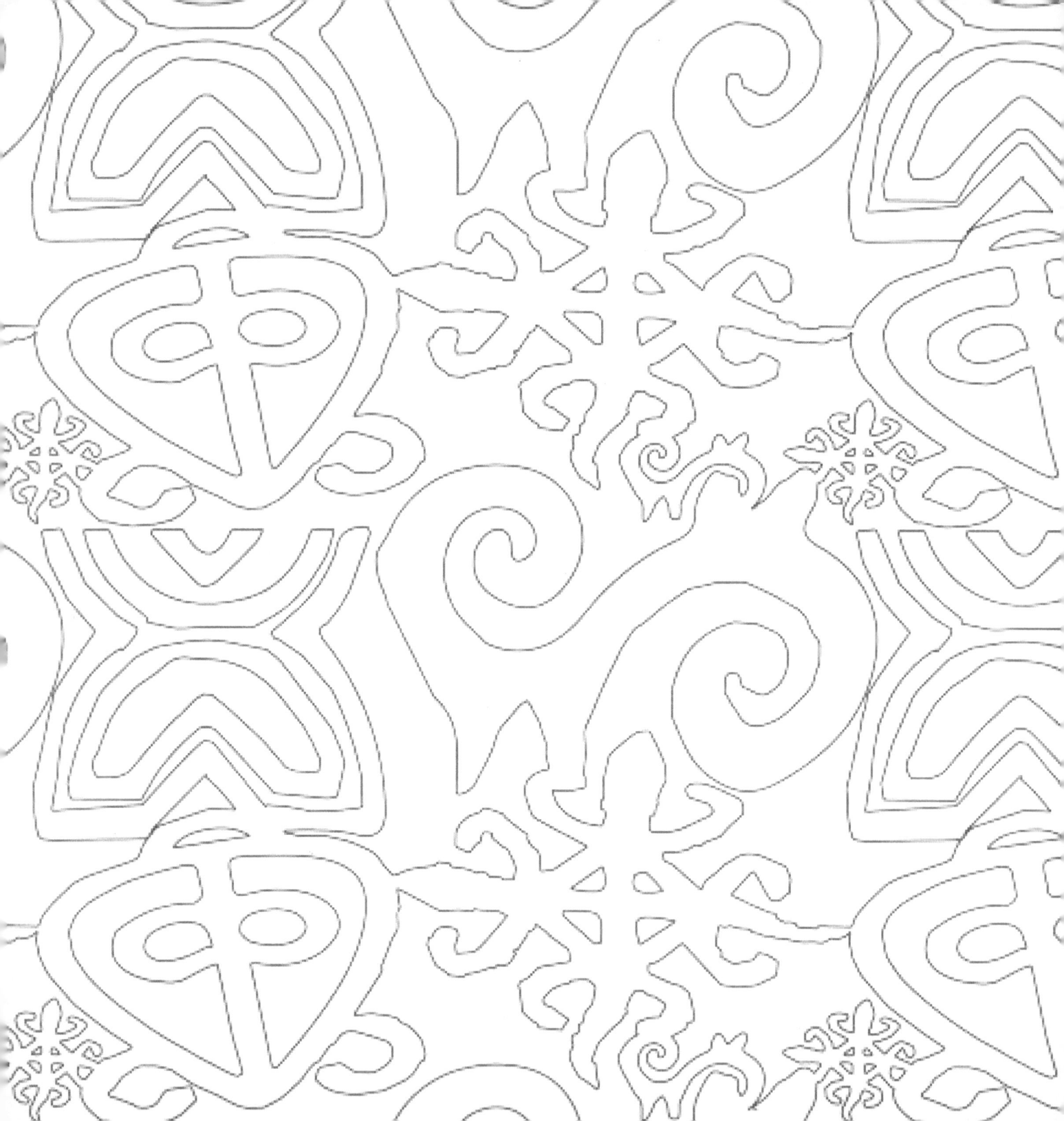

WHAT IS ADINKRA?

Adinkra are visual symbols, originally created by the Akan of Ghana and the Gyaman of Cote d'Ivoire in West Africa. They represent popular proverbs, concepts or original thoughts.
Adinkra are used on fabric, walls, in pottery, metalwork, woodcarvings and logos.
Fabric adinkra are often made by woodcut sign writing as well as screen printing.
Adinkra also can be used to communicate evocative messages that represent parts of their life or historical events.

MY ADINKRA COLOURING BOOK

PUDDY PHATT PUBLISHING

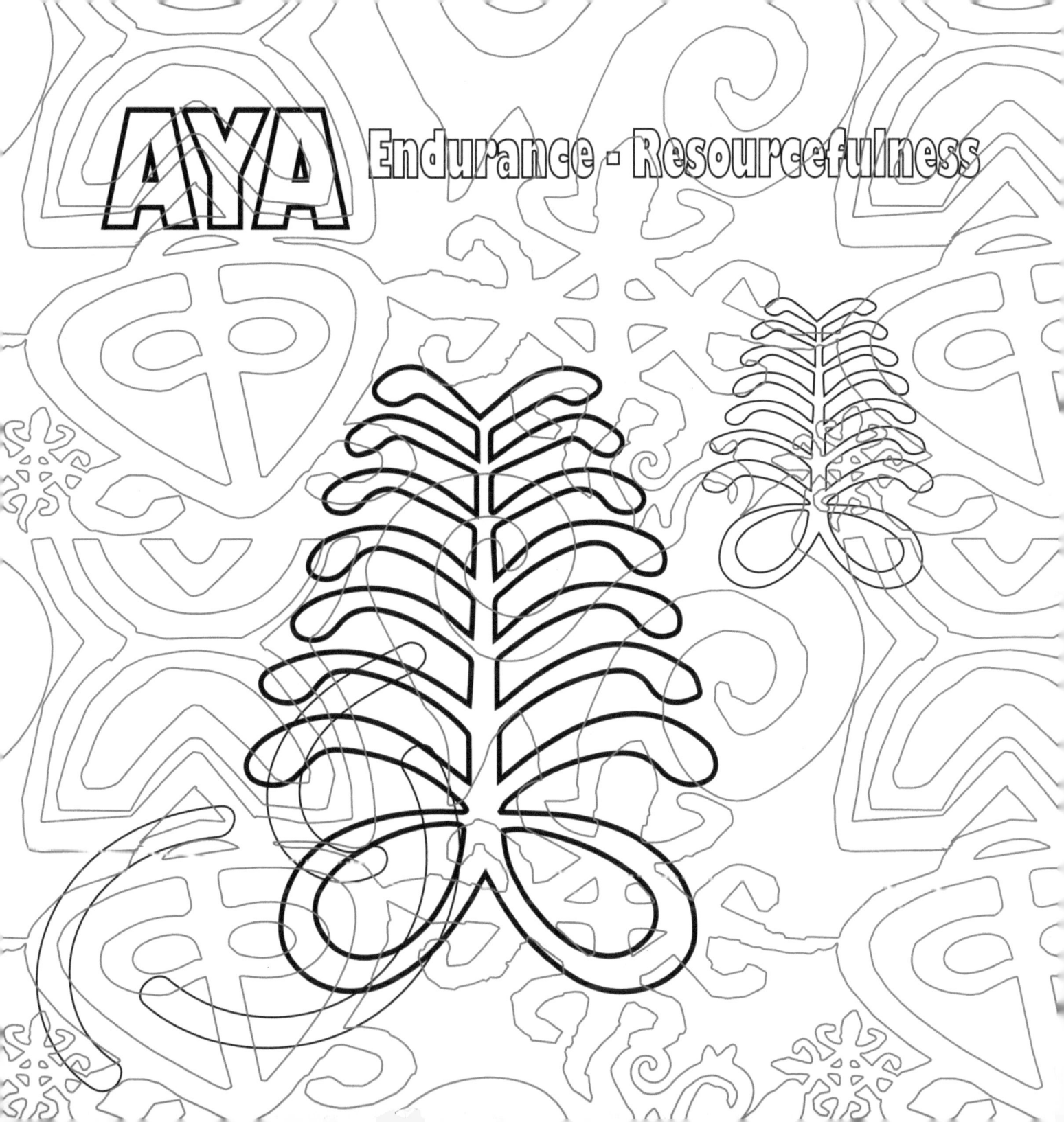

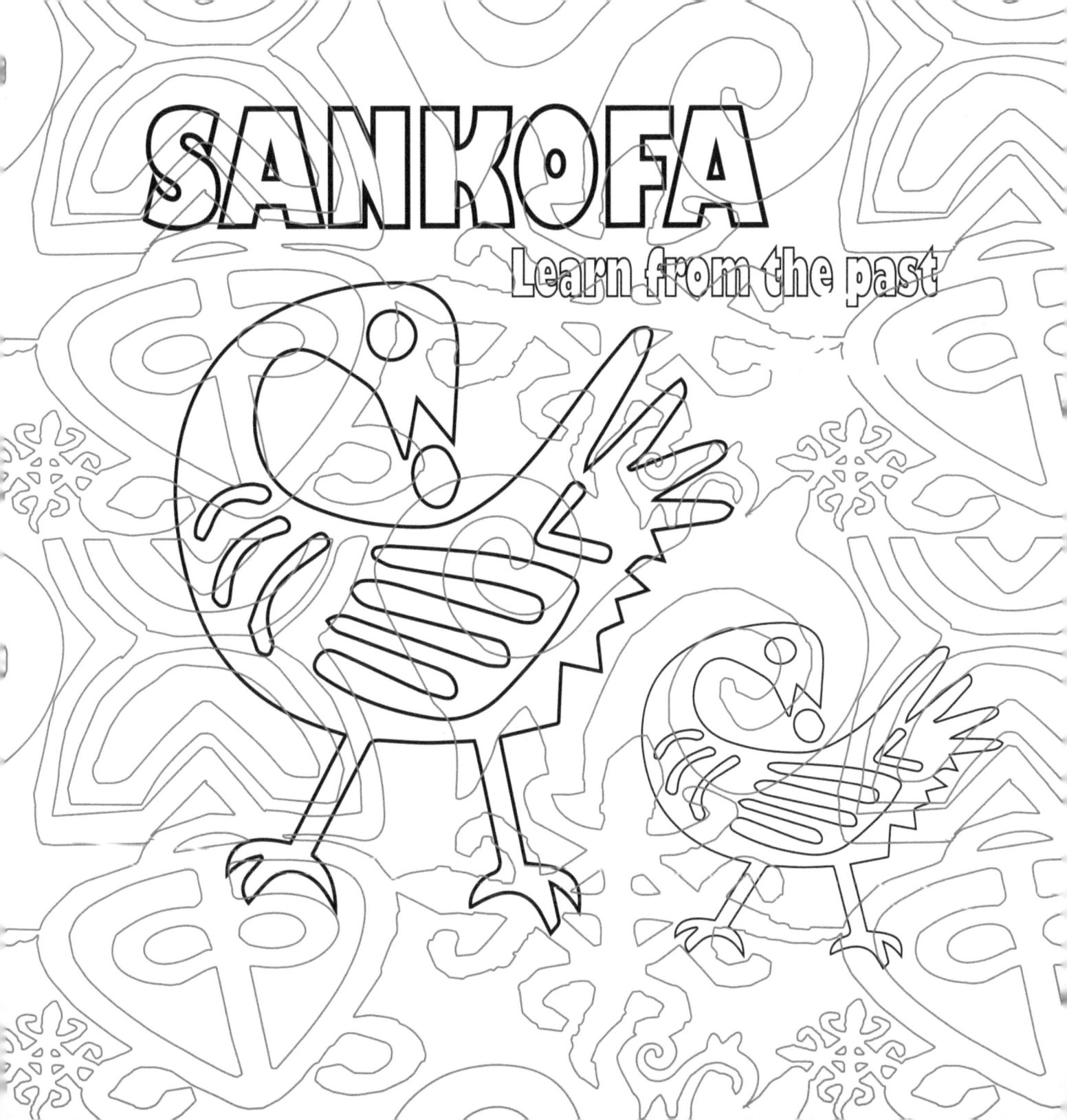

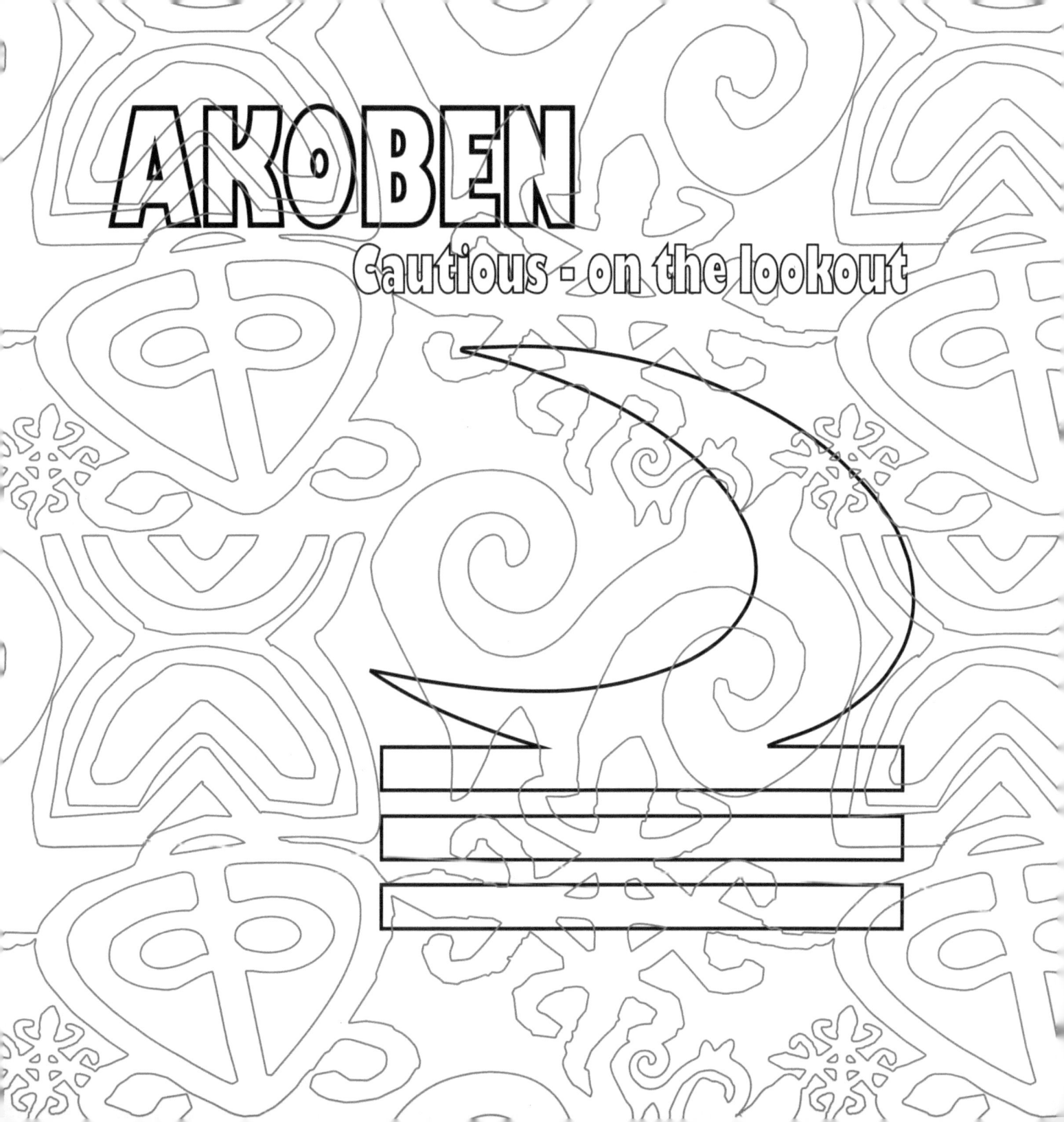

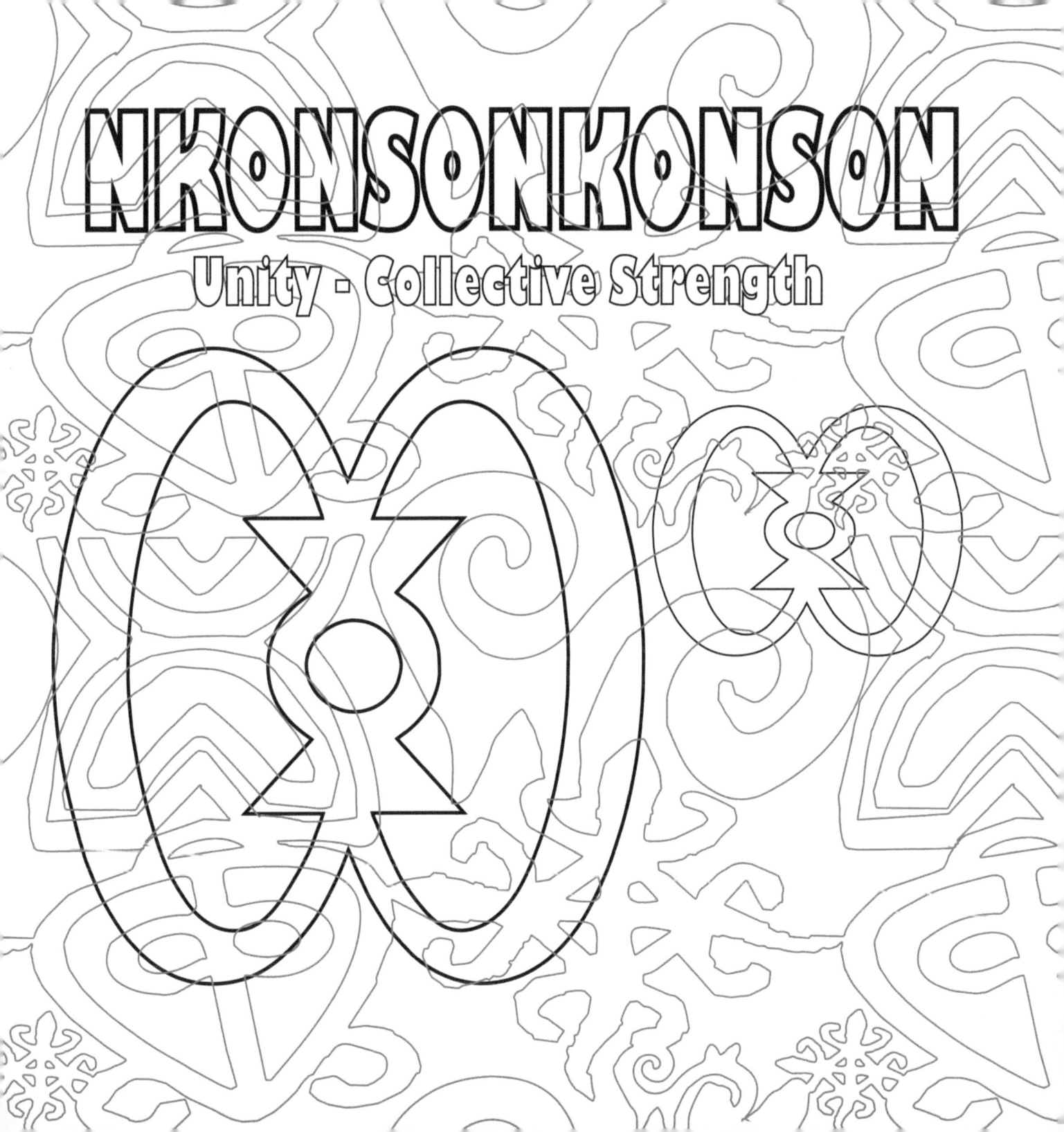

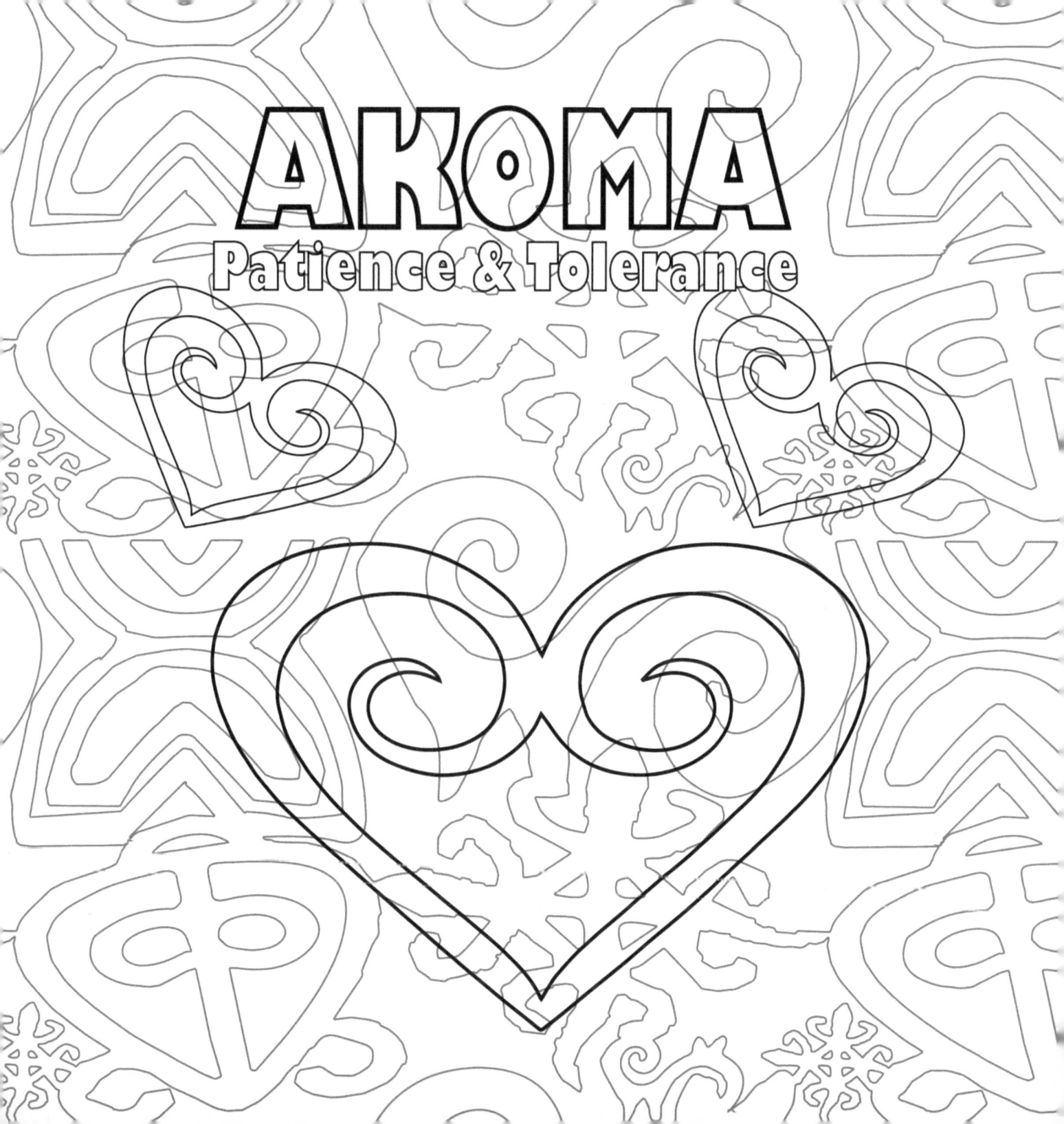

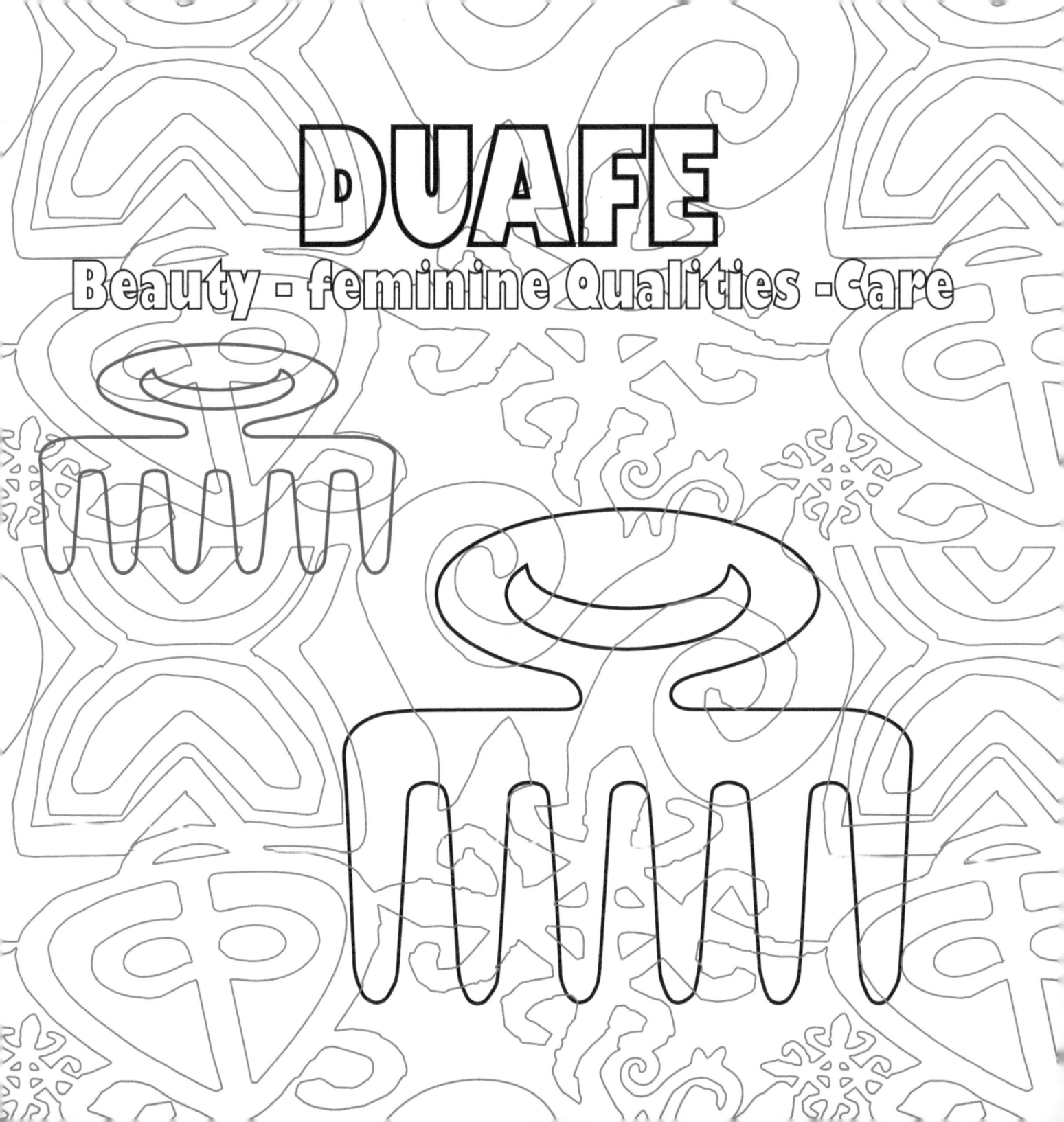

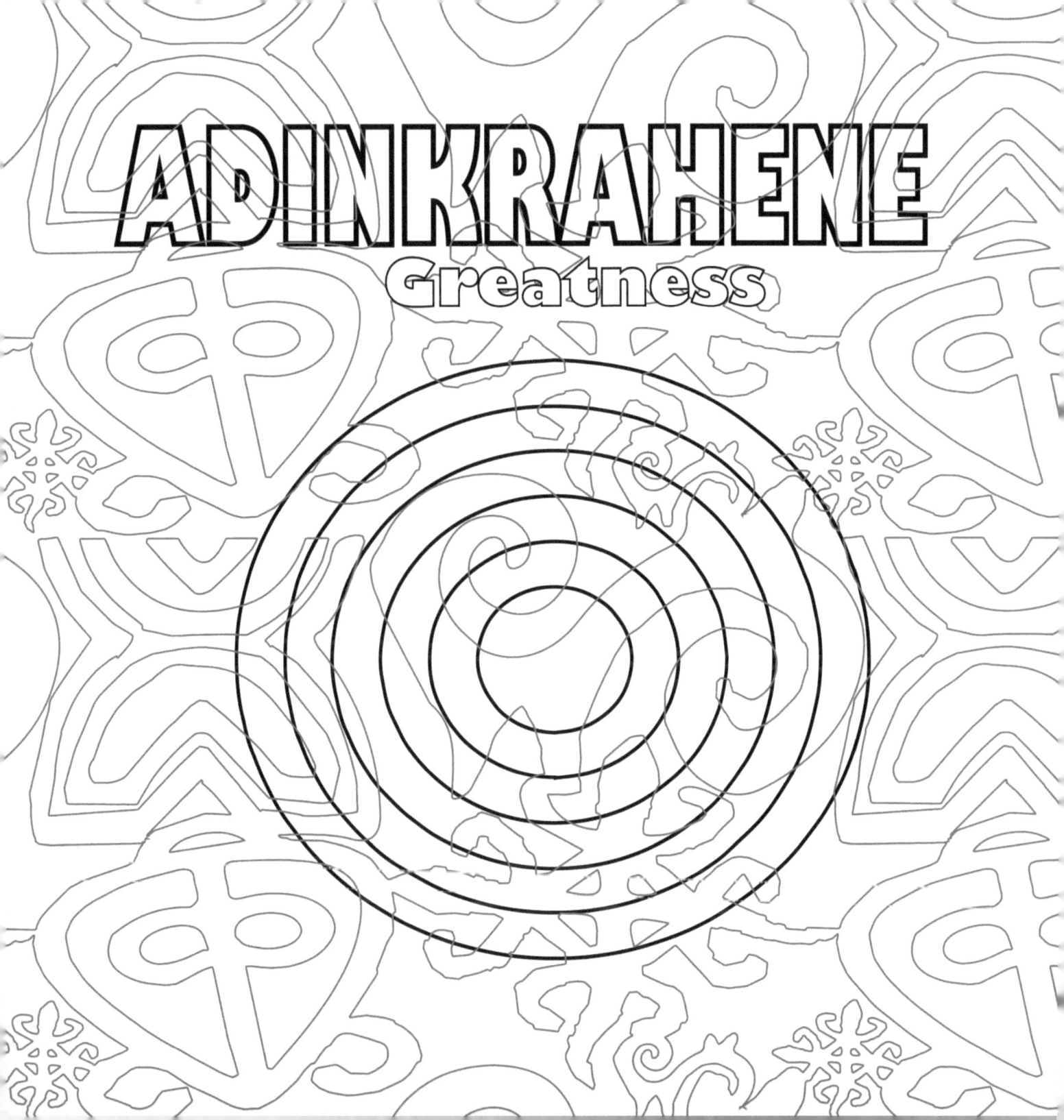

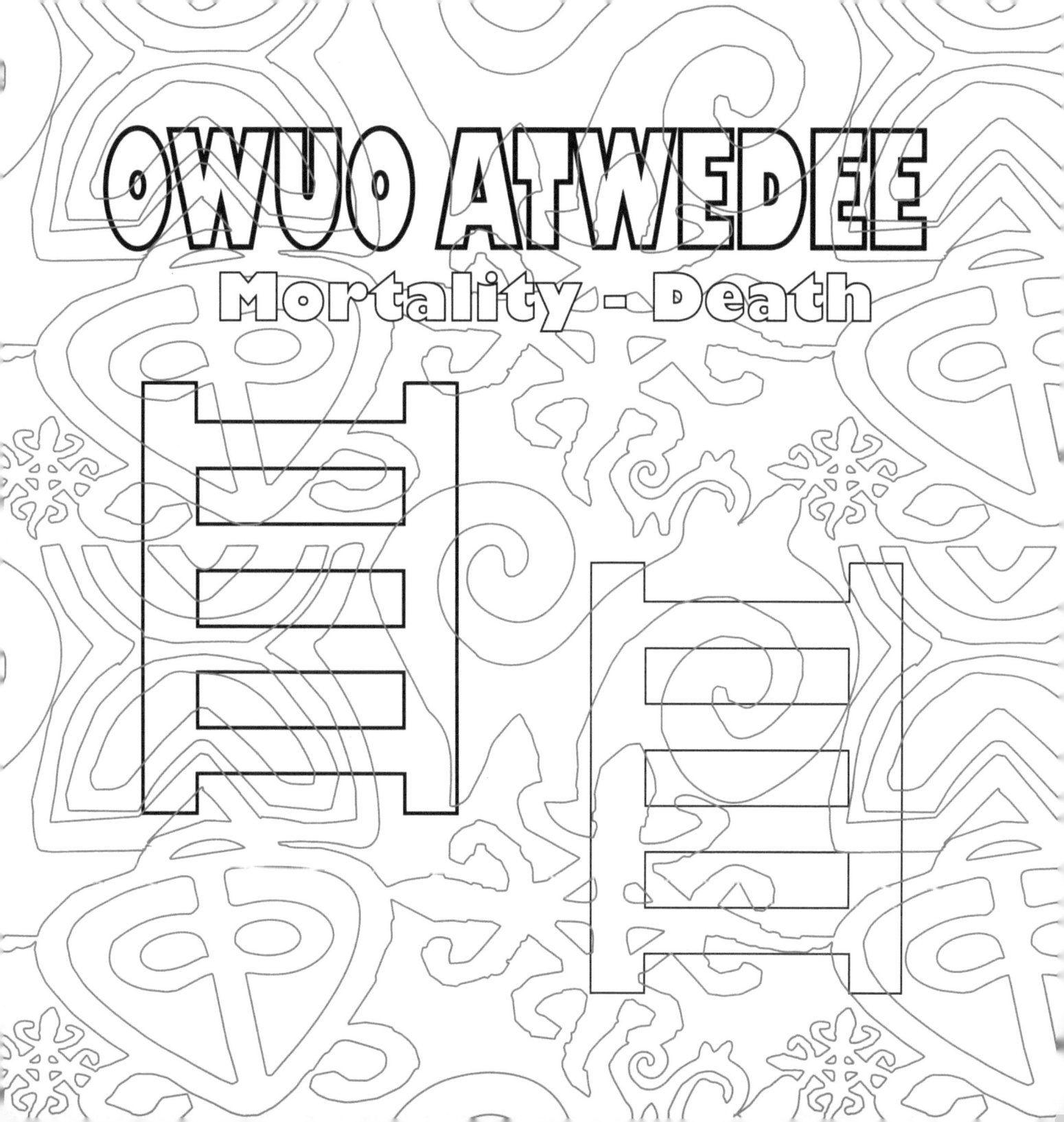

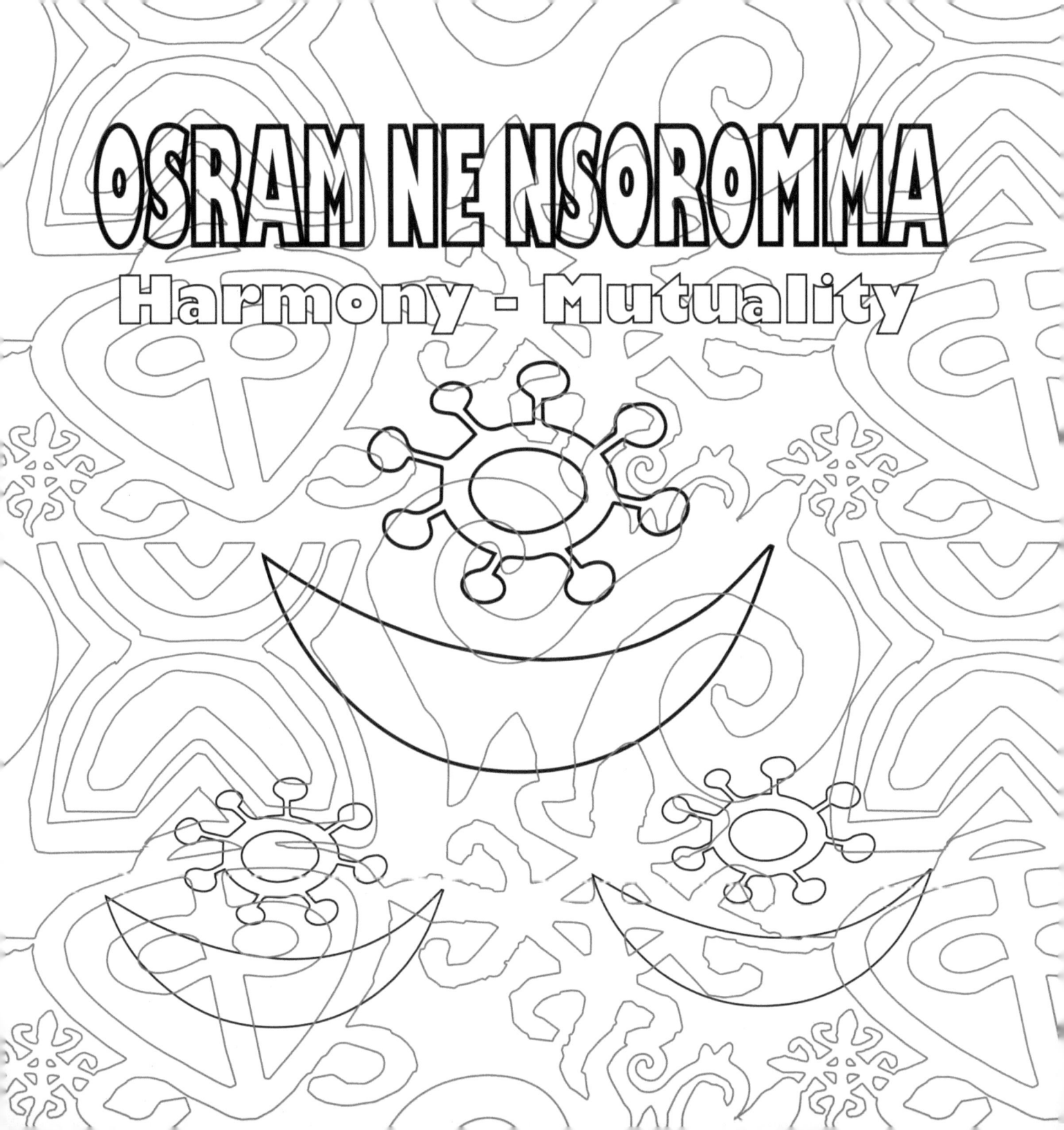

COPYRIGHT PUDDY PHATT PUBLISHING 2019

www.ingramcontent.com/pod-product-compliance
Lightning Source LLC
Chambersburg PA
CBHW041315180526
45172CB00004B/1113